215 AFRICAN AMERICAN WOMEN

YOU SHOULD KNOW ABOUT

Trivia Facts

by Gloria Leaks Gaymon

Nationwide Publishers

P.O. Box 6515

Philadelphia, Pa. 19138

Nationwide Publishers P.O. Box 6515 Philadelphia, Pa. 19138

Library of Congress Catalog Card Number: 92-61178

ISBN - 09633393-2-X

For My Son, Roddy

And

My Nephew Tony

Table of Contents

I wish to thank the following people for their support. Roddy Gaymon II, who constantly gave me constructive criticism and thought provoking ideas. My sister, Grace Leaks, who patiently read and helped with the proofreading. Sue Max, a librarian, with the Philadelphia Public School System who had good suggestions and was very supportive. David Dilliard, a worker in the Temple University library system who is very patient and helpful.

Positive images are necessary for children to grow into positive adults. On a consistent basis, we hear of the negative things that affect our schools, neighborhoods, community and nation.

In an effort to help combat negative images, this book was born. This is only the beginning of creativity. Each member of the community has the responsibility to project positive images for the future of our neighborhoods.

TO THOSE WHO ARE NO LONGER WITH ME IN THE FORM THAT I ONCE KNEW THEM

My great grandmother, Fannie Spearman Satterwhite, who sat down with me, told me stories about her great grand parents (My great-great-great-great grandparents) and the family's history. She passed on my birthday in June of 1976. I will never forget her.

My father's mother, Lillian Spearman Leaks, whom I had known my entire life. Losing her on labor day in 1990 was like losing a part of me. My mother's sister, Katherine Pitts Neely, a special aunt who always knew what to say to make you feel better. My aunt Bert who could always make you laugh no matter who angry you were. To all of my ancestors, relatives, and friends who have moved on from this life form.

DEDICATION TO THE LIVING

My mother, Lola Pitts Leaks, who in my opinion is the real story book mother, always giving of herself to her family. My son, Roddy Gaymon II, to help him maintain his respect for African American woman and all women. My father, Roosevelt Leaks, who has worked hard all of his life to provide for his family. My sister, Grace Leaks, who will be inspired by some of the facts included. My aunts, Molly Pitts, Dolly Ellis, Eleanor Williams, Olivia Barnes, Odessa Williams, Caroline Satterwhite, Iris Walker, Carrie Tate, Eleanora Crump and Lillie Young who has always shown a great deal of self-respect.

1. An Osteopathic doctor by profession, she was Pennsylvania's first elected black city council woman. A Republican, she passed in 1981. A public school in the city of Philadelphia has been named in her honor.

2. Born October 5, 1932 in Los Angeles, California, she became the first black woman elected to the United States Congress from the state of California.

3. An ex-slave, born in Washington, D.C., she was the principal of the Institute For Colored Youth (later to become Cheyney University) from 1869 to 1900. Her autobiography is entitled "Reminiscences of School Life and Hints on Teaching".

4. Starring as Ruth in "A Raisin in the Sun", she went to work "In the Balcony", "Gone are the Days", " The Incident", "Uptight" and "Buck and the Preacher". She married Ossie Davis, a former classmate from Harlem's American Negro Theatre.

5. A 6 feet 200 pound, cigar smoking woman, she drank in the saloons in the days of the west alongside men. Nicknamed Stagecoach Mary, she could outshoot anyone who crossed her.

6.	Commonly known as "Aunt Jemima", she became the advertising world's first living trademark.

7.	An author, originally from Baltimore, she wrote one of the first recorded novels published by an African-American woman, Iola Leroy or Shadows Uplifted, in 1890. Born in 1825, she published her first collection of poems, "Forest Leaves," in 1845.

8.	Born Matilda S. Joyner in Portsmouth, Virginia, she became known as "Black Patti". An opera singer, she sang at the White House in 1892.

9.	The first professionally trained black nurse in the United States, she received her diploma in 1879 from the New England Hospital for Women and Children School of Nursing located in Boston, Massachusetts.

10.	Once married to Paul Laurence Dunbar, she was dismissed as head of the English Department of a high school in Wilmington, Delaware because of political activity. She was the first black woman to serve on the Republican State Committee in Delaware.

11.	A financial genius, she aided fugitive slaves, and has been accused of financing John Brown's Raid. She challenged California's Jim Crow Laws. She passed in 1904 leaving an estate in excess of $300,000.

12. Graduating from Oberlin College in 1862, she became the first black woman to receive a bachelor of arts college degree. A native of Raleigh, North Carolina, she attended Oberlin, which admitted students in 1833, regardless of race or sex. She became the first black woman appointed to the position of principal of Washington High School in Washington, D.C.

13. A graduate of Howard University's School of Law in 1872, she was America's first Black female lawyer.

14. Nicknamed the Empress of the Blues, she was born in Chattanooga, Tennessee in 1894, one of seven children of a Baptist preacher. Discovered by Ma Rainey, she commanded top salaries of $2,000 per week during the 1920's. On September 26, 1937, she died, the result of a car accident, at the Afro-American Hospital in Clarksdale, Mississippi.

15. Born Isabella Baumfree in Hurley, New York in 1797, she has been called the Black Joan of Arc. She travelled speaking for women's rights and the emancipation of slaves.

16. Name the black woman who owned Rancho Rodeo De Las Aguas (Beverly Hills, California) in 1790.

17. She was a leading cosmetic manufacturer, a highly successful businesswoman and one of the first American female self-made millionaires. She also invented a straightening comb for black women.

18. Daughter of William Still, she graduated from Oberlin College in 1868. She was, at one time a teacher and later a practicing doctor in Philadelphia. She married Matthew Anderson, pastor of Berean Presbyterian Church in Philadelphia, Pennsylvania.

19. Known as "The Lady From South Philly", she was the first black opera singer to perform at the Metropolitan Opera House in New York City. On January 7, 1955, she made the debut as Ulrica in The Masked Ball.

20. As a result of the May 13, 1985 bombing of a Philadelphia rowhouse by city, state and federal officials, one Move adult escaped the inferno. She remained incarcerated for 7 years primarily because she refused to give up her Move philosophy of life.

21. Born in Philadephia in 1898, she became one of the first black women to earn a PH.D. in the United States. In 1927, she became the first black woman to graduate from the University of Pennsylvania's Law School. She went on to become the first black woman admitted to the Pennsylvania Bar.

22. Born a slave in Holly Springs, Mississippi in 1862, she became an anti-lynch crusader. A compiler of the first statistical pamphlet "The Red Record" on lynching, she once had her printing office vandalized for a detailed expose on lynch mobs.

23. Founder of Palmer Memorial Institute, she was its first president for 50 years. She was the first black woman to be elected to the 20th Century Club of Boston in 1928.

24. A founder of the National Council for Negro Women, she also founded a girls college in Daytona Beach, Florida. She served as a presidential advisor to Franklin Delano Roosevelt.

25. Born of parents who were immigrants from Barbados, she was the first black woman elected to the United States Congress from any state. She hailed from the state of New York. Her autobiography is entitled *Unbought and Unbossed*.

26. Publisher of Canada's first anti-slavery newspaper, *The Provincial Freeman*, she was the first black newspaperwoman on the North American continent. She was the second black woman in the United States to earn a law degree in 1883.

27. A Philadelphia Quaker, she was a faculty member of the Institute For Colored Youth and an abolitionist who also spoke up for women's rights. In 1820, she started a private school in Philadelphia for black children.

28. A gifted vocalist with 27 notes, she became known as The Black Swan and gave a performance at Buckingham Palace for Queen Victoria, in the 1850's.

29. The first black woman to serve in an official position in a President's cabinet, she was appointed by President Carter as the Secretary of Housing and Urban Development and later the Secretary of Health and Human Services.

30. An eloquent speaker, she was the first black woman elected to the state senate in Texas and the first black woman from the south to be elected to Congress in November of 1972.

31. The first black woman to earn a medical college degree in the United States, she graduated from the New England Female Medical College in Boston in 1864.

32. She helped over 300 slaves to escape from the south. Southern slave holders placed a bounty on her: Dead or Alive $40,000 reward in 1840. She has been called the Moses of the Underground Railroad.

33. The nation's first black female bank president, she organized and founded St. Luke's Bank and Trust Co. of Richmond, Virginia.

34. Born in Senegal, West Africa, she was sold as a slave in America in 1761. She went on to become one of America's first recorded black poets. She died in 1784 at the age of 31.

35. Placed in the White House of the Confederacy during the Civil War, she listened to and memorized conversations among Jefferson Davis, President of the Confederacy and his men and got them to General Ulysses Grant of the United States of America through Mrs. Van Lew.

36. A graduate of Dunbar High School in Washington, D.C., she earned both a masters degree and law degree from Yale University. President Carter appointed her as the first female chairperson of the Equal Employment Opportunity Commission.

37. An African American female, she belonged to one of the leading black families of Philadelphia. She taught in Port Royal, South Carolina from August of 1862 to May 1864. It was posthumously published in the Journals of her Autobiography.

38. The first Melrose House (New Orleans, Louisiana) was built in approximately 1750 for a freed slave who married Thomas Metoyer from Paris. The plantation house was originally called Yucca.

39. A black woman, the daughter of "Black Sam", owner of Francis Tavern, saved General Washington's life during the Revolutionary War by exposing a plot to poison him.

40. A Philadelphia born sculptress, she graduated from the Pennsylvania School of Industrial Art. Two of her famous works were The Medusa and The Wretched.

41. An Atlanta born poet, she wrote *The Heart of a Woman* in 1918, *Bronze* in 1922 and *Autumn Love Cycle* in 1928 receiving claim before and during the Harlem Renaissance. Educated at Atlanta University and Oberlin, she studied to become a composer but decided instead to become a teacher.

42. A singer, dancer and comedienne, she achieved stage success in 1922, Shuffle Along. She appeared later in *From Dover to Dixie* and *Blackbirds*.

43. A Philadelphia born sculptress, she graduated from the Pennsylvania Academy of Fine Arts. Two of her famous works were *The Mulatto Mother and Her Child*, and *Head of a Child*.

44. A female sculptress, she studied at Cooper Institute. She was influenced by African sculpture and techniques. She was most noted for her *African Savage* and *The Tom-Tom*.

45. An 1871 graduate of the Women's Medical College of Pennsylvania, she was one of the first three black women to receive medical degrees in the United States. She was born in March 1846 and was a graduate of the Institute For Colored Youth.

46. Born in 1942, in Memphis, Tennessee, she was born to a preacher and his wife. Once a gospel singer, she has been called the Queen of Soul.

47. A graduate of the University of Michigan in 1890, she was the first black woman to receive a degree in dentistry.

48. Born a slave, her mother was sold from her, never to be seen again. She established the first Sunday School in New 1790's York City, in the 1790s'. She conducted the Murray Street Sunday School for 40 years.

49. The first black female pilot, she gave stunts worldwide, losing her life in a fatal 1,500 feet nose dive at an exhibition for the Jacksonville Florida Negro Welfare League.

50. With a role as "Chick", in Ken Vidor's Hallelujah, she became the first recognized black female motion picture star. She was nicknamed The Black Garbo.

51. The first black woman to run for Congress from the second district of Mississippi, she was the founder and vice chairperson of the Mississippi Freedom and Democratic Party.

52. Organizer of the Women's New Era Club, she was instrumental in publishing the first black woman's newspaper in the United States.

53. The first black woman to receive the National Association for the Advancement of Colored People Springarn Award in 1922, at one point she was the principal of Little Rock's Union High School. She served as president of the National Association of Colored Women.

54. The first recorded black army nurse was

55. The first black woman from the state of Pennsylvania to become an elected state senator was

56. Born in Chester, Pennsylvania in 1900, married at the age of 12, by the age of 27, she had become a singer and actress. Billed as Sweet Mama Stringbean, she was the first woman to sing W.C. Handy's St. Louis Blues. Her autobiography is called His Eye is on the Sparrow. She created the character of Beulah on radio and television.

57. A graduate of the Philadelphia High School for Girls in Philadelphia, Pennsylvania, she earned both a Bachelor of Science and Masters Degree in Education from Temple University. Starting as a teacher in Philadelphia's public schools in 1955, she went on to earn a Doctor's Degree in Education from the University of Pennsylvania and became Philadelphia's first black superintendent of schools in 1982.

58. Elected to the state senate in New York in 1964, she was the first African American woman to do so. In 1966, President Lyndon Baines Johnson appointed her a federal judge, again the first black woman to attain a federal judgeship.

59. The only black student in her classes at the Philadelphia High School for Girls in Philadelphia, she graduated Phi Beta Kappa from Cornell in 1905. She is the author of the *Chinaberry Tree*, *There is Confusion*, *Plum Bun* and *Comedy: American Style*.

60. A graduate of Wellesley College and Yale Law School, she became the
 first black female judge in 1939, when Mayor La Guardia appointed her
 judge in the Domestic Relations Court of the City of New York.

61. Her autobiography "A Colored Woman in a White World" was published
 in 1940. In 1895, she was appointed to the Washington, D. C. School
 Board, the first black woman in the United States to hold the position.

62. The first black female principal of a high school in the City of
 Philadelphia, she also became the first black female president of the
 Philadelphia School Board.

63. Born in Wichita, Kansas in 1898, and co-starring in Gone With The
 Wind, she was the first black woman to win an Oscar.

64. This woman's father was a full blooded African, her mother was a full
 blooded Chippewa, yet she became America's first black sculptress.

65. Author of *A Raisin in the Sun*, a play which captured the New York
 Drama Critics Circle Award as the best play of 1958-1959, it was the first
 time a black earned the prize .

66. Born in February 1913 in Tuskegee, Alabama, tired from a days work, she
 was arrested for refusing to give up her seat on a bus to a white man. Her

arrest led to the Montgomery Bus Boycott. She is nicknamed the Mother of the Modern Civil Rights Movement.

67. A driving force behind the struggle to integrate the all white Central High School in Little Rock, Arkansas in 1957. She and her husband, at one time started their own newspaper in Little Rock called the "Arkansas State Press". She authored "The Long Shadow of Little Rock".

68. A social worker, she with the help of the Russell Sage Foundation raised money to establish the Home for Colored Girls in Peaks Turnout, Virginia. She received the Harmon Award in 1929 for distinguished service in social work.

69. Founder of the National Trade and Professional School for Women and Girls in Washington, D.C., she was denied a job by the Board of Education in Washington, D.C. She had been an associate director of the Philadelphia Christian Banner earlier in her career.

70. Born in 1805, at the age of 15, she opened the First Boarding School and Seminary for Black Girls in Georgetown on Dunbarton Street.

71. A special pride in her blackness, she toured 25 European cities between 1928 and 1930. She took personal stands against racism by refusing to

play anywhere that barred blacks as patrons. She became associated with "Parisian" beauty.

72. The first black woman to sit as a delegate in the Kentucky Republican Convention was

73. This slave, with her husband William, escaped from Macon, Georgia on December 21, 1848 and arrived in Philadelphia, Pennsylvania on December 25, 1848, traveling as a master (she was) and slave (William was).

74. The first black woman appointed to teach in the New York City public school system in a non-segregated setting

75. Appointed in 1939 as a principal in the New York City public school system, she is the first black woman of the 20th century to hold that position.

76. A female tennis player, she won 12 overseas tennis tournaments in 1956.

77. Born in Eatonville, Florida, in 1901, she was the author of *Their Eyes Were Watching God*, and *Mules and Men*, both written during the Great Depression. She became an authority on black folklore. Her autobiography is called *Dust Tracks on a Road*.

78. Born a slave in approximately 1818 Virginia she became a seamstress for both Ms. Jefferson Davis and Mary Todd Lincoln. She wrote of her experiences in "Behind the Scenes or Thirty Years a Slave and Four Years in the White House."

79. The first African American woman to be recognized as an award winning composer, one of her symphonies was performed at the Chicago World's Fair by the Chicago Symphony in 1933, a first for a black female composer. Born in 1888, Little Rock, Arkansas, she is remembered for her arrangement of "My Soul Been Anchored in the Lord".

80. The first American born woman to lecture in public, she made her first speech in Boston in 1832, five years before Angelina and Sarah Grimke took to the public lecture.

81. One of the first African American women to formally enter the medical profession and gain recognizable success, she graduated from the New York Medical School for Women and Children as valedictorian in 1870. The first black female doctor in New York, she is the sister of Sarah Garnett.

82 A poet and playwright, born in Birmingham, Alabama in 1935, she lived in New York, studied at New York University and Hunter College. She

wrote *We Baddddd People* and *Home Girls and Home-Grown Grenades*.

83. A slave girl at age 16, she authored in 1746, a poem which described a Indian Raid on her village of Deerfield, Massachusetts. It was entitled *Bar Fight* August 28, 1746.

84. A free black female slaveowner and woman of means of New Orleans, Louisiana, she left property upon her death in 1837 for the establishment of a school for colored orphans.

85. An 1856 graduate (diploma) of Oberlin, she was the first black woman to teach at Wilberforce University.

86. Born in Norfolk, Virginia in 1823, she was privately educated. She organized the Daughters of Zion to assist runaway slaves after moving to Hampton, Virginia. In September of 1861, she opened a school in Hampton, with the assistance of the American Missionary Association.

87. Founder of Denmark Industrial School in 1897 which later became Voorhees Industrial School in 1902 and later Voorhees College, she was an 1894 graduate of Tuskegee Institute.

88. Educated in Cambridge, Massachusetts, she was the first black teacher in Cambridge and the first black principal in Massachusetts (1889).

89. Author of *Love my Children, The Autobiography of a Teacher*, she was the first black woman to receive a PH.D from Harvard University (Graduate School of Education, 1937).

90. Co-founder of a teaching order, Oblate Sisters of Providence, she founded the St. Frances Chapel of the Oblates, the first church in the United States for black Catholics.

91. The first black woman admitted to the Chicago Library Board, she founded the first training school for black nurses in Chicago.

92. Born a slave in Macon, Georgia in April of 1864, she entered Atlanta University at the age of 15 and graduated in the first class of 1873. She founded Haines Normal and Industrial Institute in Augusta, Georgia.

93. Born in January 1944, Birmingham, Alabama, she graduated from Brandeis University and studied in France. She was active for prisoner's rights and as a result was implicated in the Soledad brothers shootout in 1970. Placed on the Federal Bureau of Investigation's (FBI) 10 most wanted list, she is a university professor and author of *Women, Race and Class*.

94. Nicknamed the Hossier Lady, she was Indiana's first black Congresswoman.

95. Born in 1855, in Pittsburgh, Pennsylvania, she was raised in Ontario, Canada. A teacher between 1905 and 1912, she was leader of both the Ohio State Federation of Women and the National Association of Colored Women. She was author of *Homespun Heroines and Other Women of Distinction*.

96. The first black woman admitted to the bar in Mississippi was in 1966. Organizer of the Children's Defense Fund in 1973, she is author of *Families in Peril: An Agenda for Social Change*. She also became the first black female elected to the Yale University Board of Trustees in 1972.

97. Paulette Williams was her birth name. She authored *For Colored Girls Who Have Committed Suicide When The Rainbow Is Enough*. What is her Zulu and pen name?

98. In the 1960's, she established the Institute For The Study of Black Life And Culture at Jackson State College. Jubilee was presented with a Ph.D. dissertation at the University of Iowa in 1966 and won a Houghton-Mifflin literary fellowship award. Name the author.

99. A graduate of the Philadelphia High School for Girls in Philadelphia, Pennsylvania, she is the author of Sally Hemmings. An acclaimed

sculptress, she dedicated her first one woman show to Malcolm X. Name her.

100. A native of Atlanta, Georgia, she was the first black woman to be seated in the Georgia legislature, in 1966.

101. The first black female judge in Washington, D.C. was in 1962. Name her.

102. Elected to the United States Congress in 1974, she was the first black woman from the state of Illinois to serve in Congress.

103. Born in 1882, in 1926, she became the first black woman admitted to practice before the United States Supreme Court.

104. The first black president of the American Library Association, she also was the first black director of the Detroit public library.

105. The nation's first African-American female to become an elected municipal court judge was in 1959. She was elected to office in Philadelphia, Pennsylvania.

106. Born Eleanor Fagan Gough in 1915, Baltimore, Maryland, she was a blues singer nicknamed Lady Day.

107. An educator in Georgia from 1963 to 1968, she was appointed a judge in Sparta, Georgia, becoming the first black judge in Georgia.

108. Author of *Quicksand and Passing*, she was the first black woman to receive a Guggenheim Award.

109. Her autobiography is entitled, *I Know Why The Caged Bird Sings*. She, at one point in her life wrote articles for the African Review in Accra, Ghana and the Arab Observer in Cairo, Egypt.

110. She enlisted in the Fourth Massachusetts Regiment in 1782 during the American Revolutionary War as Robert Shurtleff and served to the end of the war. She was later honored by the Massachusetts State Legislature for female heroism.

111. Born a slave in 1853, her owners sent her to music school. Her contralto voice became one of the outstanding voices of the Jubilee singers. She died on ship during a heavy storm in 1896. She is buried in Athens, Alabama.

112. A Virginia born slave who purchased her freedom in 1856, she traveled to Colorado during the Gold Rush. Settling in Central City, she was instrumental in the development of the St. James Methodist Episcopal Church of Central City.

113. Born in 1816, this mulatto woman's admission to Prudence Crandall's Select School For Girls in 1832 in Canterbury, Connecticut led to a great controversy. The school was closed on September 9, 1834, the same day that she gave birth to a child she named Prudence Crandall.

114. Born in 1913, she died in 1972. Earning a masters degree from Northwestern University, she also studied at Juillard. Her awards and fellowships included a Rosenwald, a Roy Harris and a Wanamaker. One of her most popular works "The Ballad of the Brown King" is performed annually in black churches.

115. A soprano, she was the first black woman to sing with a major American company. She sang the title role in Aida with Alfredo Salmaggi's Chicago Opera Company in the New York Hippodrome in 1933.

116. A soprano, she was the first black woman to become a regular member of an American Opera Company. She sang the role of Cio-Cio-San in Madame Butterfly in 1946. Winner of the Marian Anderson Award in 1943 and 1944, she gave a special performance at the White House in 1960.

117. She was the first black leading soprano to sing at the Metropolitan Opera. She made her debut as Gilda in Rigoletto in 1956.

118. In July of 1950, in Gian Carlo Mcnotti's Opera, The Medium, she became the first African American woman to play a leading "white" role on Broadway. Hailing from Cleveland, Ohio, her thesis was entitled A Guide to Negro Music: An Annotated Bibliography of Negro Folk Music and Art Music by Negro Composers or Based on Negro Thematic Material. It has 12,000 plus titles of black music and literature about it.

119. Holding the title of "Prima Donna Assoluta", she was born in Laurel, Mississippi. A graduate of Central College in Ohio, her intentions were to become a teacher. After attending Julliard School of Music in New York City, she performed Bess in Porgy and Bess. She made her debut at the Metropolitan Opera in II Trovatore in 1961, for which she received a standing ovation of at least 30 minutes.

120. Soprano, Harlem born, Prima Donna, she has appeared in London at the Royal Opera, Vienna at the Staatsoper, Buenos Aires at Teatro Colon, Milan at Teatro All Scala, and the Metropolitan Opera House in New York City. She has also sang with the Cleveland Orchestra Boston Symphony.

121. Appearing in the movie version of *New Faces*, she also appeared in *Anna Lucasta* with Sammy Davis Jr. and Rex Ingram, **St.** *Louis Blues* with Nat King Cole, *The March of the Hawk, Synanon*,

and as Catwoman in the Batman Television series. Her autobiography is entitled *Confessions of a Sex Kitten*.

122. Author of The Bluest Eye, Sula, and Song of Solomon, she was born in Lorraine, Ohio and attended Howard and Cornell Universities.

123. Accused of being a witch in 1692, in Salem, Massachusetts, she was tried in the colonial courts and sentenced to death. Although she confessed, she said that her master Reverend Parris had beaten her until she agreed to confess. Saved from execution, she was sold to pay her jail fees.

124. Born Gertrude Pridgett in 1886, she was nicknamed "Mother of the Blues". She became the first black female blues singer in a male dominated field. She entertained from the turn of 20th century to the Depression Era.

125. Nicknamed Queen of the Mothers, she was born in Spartanburgh, South Carolina in approximately 1894. She was a best selling blues artist for Columbia records, second in sales only to Bessie Smith, of which she was not related.

126. The first blues singer on records, her first recording of Crazy Blues sold 75,000 copies in one month in 1920. She made nearly 100 records in 7 years, yet she died broke in 1846.

127. Born Loretta May Aiken in 1897, she was called the Funniest Woman in the World. Traveling the chitlin' circuit, she became the first black female comic star to stand alone. A classic line of hers "There ain't nothing an old man can do for me except bring me a message from a young one" shows how roughly she handled men in some of her performances.

128. Nicknamed the Uncrowned Queen of the Blues, she was born in 1889 in Knoxville, Tennessee. In the late 1920's, she toured with her own road show versions of Raisin Cain and Dark Town Scandals.

129. Nicknamed Queen Victoria, she wrote most of her songs and played the piano and-organ. She returned in 1962 to sing at Carneige Hall after a semi retirement in the 1950s. She passed in 1976.

130. Nicknamed the Chicago Cyclone, she gave up her music career after 1934 to become a registered nurse. Born in 1894, she toured with her own groups, the Blue Flame Syncopators and the Dixie Daisies for a time in the 1920's.

131. The first black woman to earn a master of music degree from the Chicago Musical College in 1918, her married life began at the age of 15. In 1938, she studied at the University of Southern California, taught school,

operated a beauty parlor and served on the Board of Education in Los Angeles.

132. Called the Idol of Dreamland, as a result of her performances at the Dreamland Cabaret in Chicago, she became known as a tough little cookie who could take care of herself. Author of Downhearted Blues which was popularized by Bessie Smith, she was one of the first singers to record the blues.

133. Born in Wooster, Ohio in 1890, she attended Radcliff from 1919 to 1923. She dramatized her husband's (Dubose Heyward) novel Porgy, which was transformed into George Gerswhin's opera Porgy and Bess.

134. Author of *Shape Them Into Dreams*, she won the Opportunity (National Urban League Magazine) prize in 1926 for her dialect poem "Northborn". Born in 1905, Alabama, she became Director of Music at North Carolina College in Dunham.

135. Daughter of the first black female millionaire, she became known for her lavish parties and lifestyle. Her funeral in 1931 was like a party with Langston Hughes poem "To A'Lelia" being read, Reverend Adam Clayton Powell Jr. delivering the eulogy, Mary McCleod Bethune speaking, and four bon bons singing Noel Cowards' "I'll See You Again".

136. Born in Hartford, Connecticut in 1887, she studied at the Pennsylvania Academy of Fine Arts in Philadelphia. She was an art instructor at Cheyney University from 1926 to her death in 1948. She was known for her portraits depicting African American life.

137. Starring as Peola, daughter of Louise Beavers in the original Imitation of Life, she was born in Georgia in 1903. Green-eyed, fair skinned, she was often urged to pass for white in real life.

138. Billed in the late thirties as the First Lady of Song, she was born in Newport News, Virginia. She had the ability to sing ballad, calypso, dixieland jazz, pop and swing. She recorded 2000 plus songs and at least 70 albums.

139. A pin up girl for black military men during World War II, she performed in a successful one woman show during the 1980's. She was born in 1917 in Brooklyn, New York. Starting as a cabaret singer, she became the first black woman with a long term contract with a major Hollywood studio.

140. Nicknamed Pig Foot Mary, she turned a $5.00 investment into a small fortune. Born in 1870, Mississippi, she cooked and sold pigs feet in New York City in 1901. Expanding her street corner business to later include hogmaws, chitterlings and corn on the cob, she was able to stand on her

own two feet. She invested in real estate after her marriage to John Dean, the shoeshine man whose stand was near her food operations.

141. A graduate of the University of Chicago, she has been called Gerry Major. Her vocations, at one point, included teaching, publicity agent, social columnist and the first black female announcer over the commercial radio station WABC, for CBS. Her regular program on WABC was entitled The Negro Achievement Hour.

142. Recipient of a Rosenwald Travel Fellowship, she published an account of her studying and traveling in "Journey to Accompong". Awarded a bachelor of arts degree in anthropology from the University of Chicago, her dance troupe became famous for its dances of Caribbean origins.

143. Born in Trinidad in 1920, by age 13, she had mastered the musical classics. She appeared on Broadway at age eighteen in "Sing Out the News". Her album, Swinging the Classics almost broke sales records. She was once married to Adam Clayton Powell Jr.

144. She made one of her most successful film appearances in **Porgy and Bess**, and **Carmen Jones**. Born in Cleveland, Ohio in 1922, she became one of the first black women to see her face on a *Life* magazine cover. She was one of the first black women in film that found themselves in the arms of white men. She died of an overdose of pills.

145. An African American folk singer, she gave her first major concert at Town Hall in 1959.

146. Born in Newport News, Virginia, daughter of a preacher, she received the Donaldson Award for her role in the 1946 Broadway production St. Louis Woman. She was America's first black television star. In 1952, she married white drummer Louis Bellson in London.

147. Nicknamed the "Black Marilyn Monroe", she was the daughter of a Seventh-Day Adventist. Known for her skintight, backless, fishtail dresses, she also sported blond hair. Earning as much as $150,000 annually in the early fifties, two of her sexy hits, Love for Sale and Drunk with Love, were banned from radio play.

148. Born in Harlem, her parents were immigrants from Nevis Islands in the West Indies. She received an Oscar nomination for best actress in Sounder. Starring in the **Autobiography of Miss Jane Pittman**, she was, at one time, married to jazz great, Miles Davis.

149. The first black to win the Pulitzer prize for poetry, it was a result of her second volume of poems, *Annie Cullen*. Born in Topeka, Kansas in 1917, she is also author of *A Street in Bronzeville*, *Bronzeville Boys and Girls*, and *The Bean Eaters*.

150. Born in 1815, Salem, Massachusetts, to parents whose home served as headquarters for abolitionist lecturers such as William Lloyd Garrison and William Wells Brown, she was a lecturer for the Massachusetts Anti-Slavery Society. In 1859, she took her anti-slavery message to England, Scotland, and Ireland, leaving the United States permanently after the Civil War.

151. Born in 1871, Cincinnati, Ohio, she authored *The Negro Trail Blazers of California*. Her newspaper career began at the age of 12 as she wrote for the Cleveland Gazette. She fought against discrimination and humiliation of blacks.

152. Born in 1867, New Bedford, Massachusetts, she was the first black graduate of the Normal Training School for Teachers in New Bedford. She established the New Bedford Home for The Aged. In 1908, she became the 4th president of the National Association of Colored Women.

153. Born in 1877, in Stanton, Virginia, she was a branch president of the National Association for the Advancement of Colored People between 1925 and 1931 in Des Moines, Iowa. She published "History of the Order of the Eastern Star Among Colored People" in 1925.

154. Founder of The Women's Baptist Church Missionary and Educational Society of Virginia, she was born in Richmond, Virginia. She was also a founder of the Richmond Hospital.

155. An organizer of the Kansas City branch of the National Association for the Advancement of Colored People, and the Kansas City Federation of Colored Charities, she established the Jackson County Home for Negro Boys. A republican, she set up the Home Seekers and Loan Association of Kansas City to help blacks and was the largest stockholder of People's Finance Corporation in Kansas City.

156. Born in 1858, in Raleigh, North Carolina, she was the teacher and principal of the old M Street high school in Washington, D.C., (later to be called Dunbar) for 50 years. Author of *A Voice From The South*, in 1892, she received a doctor of philosophy degree from Sorbonne in Paris.

157. Author of Story of the Illinois Federation of Colored Women's Clubs 1900 to 1922, she was one of the first three blacks to graduate from the Bureau County High School in Princeton, Illinois. Born in 1855, she organized the Phyliss Wheatley Club in 1896.

158. Born to farmers in 1831, she began teaching at the age of 14 for an annual fee of $200.00, becoming a grammar school principal in the borough of

Manhattan, the first black woman to hold such a position in the 19th century. Her second husband was Reverend Henry Highland Garnett. Founder of the Equal Suffrage League in Brooklyn, she died at age 79 in 1911.

159. Author of *The Colored Girl Beautiful*, she was born in Detroit, Michigan, in 1867. She sponsored folk music festivals for black music. A composer, her most notable was *Carola*.

160. Author of *Negro Musicians and Their Music*, she was also a pianist and lecturer. Born in 1874 in Galveston, Texas, she published a volume of folksongs after traveling entitled *Creole Songs*.

161. Author of *The Work of the Afro-American Woman*, in 1894, she was born in 1855, Philadelphia, Pennsylvania. She served as an editor of the women's department of two newspapers, *The New York Age* and *The Indianapolis World*.

162. Frustrated with the results of the Chicago Public School System, she decided to open a school, Westside Prepatory in her home. Successful at reaching students who had been labeled unreachable, she received national recognition for her work.

163. Her play, *Gold Through The Trees*, became the first play by an African American woman professionally produced on stage in America. Author of the novel, *A Hero Ain'T Nothing But A Sandwich*, and the plays "Trouble in Mind " and "Wedding Band", she was born in 1920 in Charleston, South Carolina.

164. She won the American Book Award and the Pulitzer Prize for *The Color Purple*, which was made into a movie and nominated for 11 Academy Awards. A deep concern about women's issues, she was born in Eatonton, Georgia.

165. Born in 1960, Brooklyn, New York, she was the first black woman to have a solo exhibition in the painting and sculpture department of the Museum of Modern Art in New York city. She was the first black woman whose work was exhibited in the Venice Biennali.

166. An Atlanta, Georgia woman, born in 1910, she was the leader of her own jazz band by the age of 16. She established the Bel Canto Foundation to help fellow musicians involved with alcohol or drugs. A gifted composer and arranger, she wrote for Armstrong, Ellington, Goodman and others.

167. Nicknamed The Divine One, she was born in 1924, Newark, New Jersey, where she played piano and sang in the church choir. She recorded both jazz and popular songs.

168. Born Eunice Kathleen Waymon, her first success came in 1957 to I Love You Porgy. Known for speaking her mind, she put music to To Be Young Gifted and Black and The Backlash Blues. She composed Four Women and sang Mississippi Goddam.

169. A native Philadelphian, she received the Candace Award from the National Coalition of 100 Black Women in 1990. Alvin Ailey created a dance "Cry" for her. She starred in Sophisticated Ladies on Broadway.

170. Winner of 3 gold medals in the 1988 Olympics held in Seoul, Korea, she is nicknamed Flo-Jo. Born in 1959, Los Angeles, California, she was known for competing in flashy bodysuits and long fingernails.

171. At age 32, she walked from Mississippi to California, behind her master's wagons. Gaining her freedom in 1856, she acquired land through her skills as a midwife. Within a few years, she was donating money to churches, schools and nursing homes. She was one of the founders of the First African Methodist Church in Los Angeles.

172. She became Nashville's first black female co-anchor of the evening news in 1973. Born in 1954, she won an Academy Award nomination for a role in the Color Purple. She became the first woman to own and produce her own talk show.

173. The first woman to receive a law degree from Loyola University, she gained recognition as a leading lawyer in Chicago. Born in 1901, she was the first black American to serve as a United Nations alternate delegate in 1950.

174. The first black Miss America represented the state of New York in the competition. Although she lost the title near the end of her reign, she went on to become a popular and successful singer.

175. Nicknamed the Queen of Gospel Song, she was born in New Orleans, Louisiana in 1911.

176. A female group, they gave Motown Records of Detroit, Michigan, its first number one hit in 1961 with Please Mr. Postman.

177. Dana Owens, of East Orange, New Jersey, one of the positive female rappers, named one of her albums "Hail to the Queen". An individual who has been celebrating Kwanzaa with her family for a number of years, what is her entertainment name?

178. Rap artist, from south central Los Angeles, whose album is called "Make Way For the Motherlode" tell women not to take abuse lightly. Discovered by Rap Artist Ice Cube, she also founded a group which she calls The Intelligent Black Women's Coalition.

179. Queens born, Brooklyn raised, she did not have a hard time getting into the music industry because her father owns the record label that she raps on. A participant in the Human Education Against Lies Project (H.E.A.L.), followers have watched her grow as a young woman.

180. Self-assured and confident in her identity as an African American female, she grew up in Brooklyn and attended Calvary Baptist Church. Inspired by Paula Giddings' When and Where I Enter, KRS-ONE (Chris Parker) of Boogie Down Productions is her brother-in-law. What is her entertainment name?

181. A teenager from Detroit's projects, she became the lead singer for Motown's Supremes. Winning an Oscar nomination for her portrayal of Billie Holliday in Lady Sings the Blues, she also starred as Dorothy in The Wiz.

182. Born in Brooklyn's projects, she partially grew up in Englewood, New Jersey. Called a raptivist, she attended Rutgers University in New Jersey and spent time in Zimbabwe and Spain. A Public Enemy performer, she feels that you should know your enemies from your friends.

183. The first African American woman in the United States to become an elected state legislator, she was elected to the Pennsylvania State House of Representatives in November of 1938. Born in Princess Ann, Maryland,

she was raised in Boston and received a B.S. degree from Columbia University Teachers College. She passed in 1965.

184. Born in 1940, Tennessee, a scarlet fever and polio victim, she went on to earn the title of the World's Fastest Woman. A star basketball player in high school, she became the first woman to win 3 gold medals in track at the 1960 Olympics.

185. Nicknamed Queen of the blues, she mixed gospel, blues and ballad-singing, the combination which later would be called soul music. Born in Tuscaloosa, Alabama in 1924, she was raised in Chicago.

186. Called the Texas Nightingale, she was born in 1898, Houston, Texas. Her first recordings, Shorty George and Up The Country Blues, on the Okeh record label, sold close to 100,000 copies. She was born Beulah Belle Thomas.

187. The second black woman to win an Oscar, she won it for a role in the movie Ghost. She also received an oscar nomination for her role in The Color Purple. A comedienne, she also appears in Star Trek: The Next Generation.

188. Born a slave in Maryland, in 1837, her father purchased most of the-family's freedom. Her first husband disappeared in the Civil War, the

second husband and children had died by 1869. Evangelizing, she traveled the United States, England and West Africa. She opened a home for black orphans in Harvey Illinois in 1899.

189. An organizer for the civil rights movement, she was born in Norfolk, Virginia in 1902 but grew up in North Carolina. A one time president of the New York branch of the National Association for the Advancement of Colored People, she advised Dr. Martin Luther King with the Southern Christian Leadership Conference formation. Nicknamed the "Mother of the Student Nonviolent Coordinating Committee (SNCC)", she helped to found the Mississippi Freedom Democratic Party in 1964.

190. President of the Martin Luther King Jr. Center for Nonviolent Social Change in Atlanta, Georgia, she was born in Marion, Alabama in 1927. Pursuing a music career, she met and married a man whose activities would change her life forever.

191. The world's first black female astronaut, she was born in Decatur, Alabama in 1956 and raised in Chicago. She graduated from Stanford University with 2 bachelor of arts degrees. She joined the Peace Corp after graduating from Medical School and worked in Africa.

192. A child psychiatrist and educator, she received her medical degree from Howard University's Medical College. Author of The Cress Theory of

Color Confrontation and Racism, she is a member of the National Medical Association, American Medical Association and American Psychiatric Association.

193. Born in 1870, educated in the public school of Metropolis and Peoria, Illinois, she founded Poro College (St. Louis, Missouri) for beauty culture. She donated frequently to the YMCA of St. Louis, Howard University, and to the St. Louis Colored Orphans Building Fund. In 1925, she is said to have been the richest black woman in the United States.

194. Born in Jacksonville, Illinois (1908), she was the founder of Saints Junior College in Lexington, Massachusetts. She served as vice president of the National Council of Negro Women from 1954 to 1958.

195. A graduate of the Women's Medical College of Pennsylvania in 1892, she was born in Bridgewater, Pennsylvania in 1865. Founder of the first nursing school in southeast Georgia in 1893, she also established the McKane Hospital for Women and Children in Savannah, Georgia.

196. The first black woman to receive a diploma from Oberlin was in 1850. Visitors to the public school system of Toledo, Ohio objected to her presence.

197. A former nurse from Ithaca, New York, she became America's first black airline stewardess in 1958. She worked for Mohawk Airlines.

198. The first black member of the Daughters of the American Revolution was

199. The first black female native South Carolinian to practice medicine, graduated from the Women's Medical College of Pennsylvania. She organized and operated one of the first hospitals in Columbia, South Carolina, serving African Americans. She was one of the founders of the Negro Health Association of South Carolina.

200. The first recognized African American writer of science fiction, she was born in Pasadena, California in 1947. Author of Kindred , Clay's Art and Image, she sold her first 2 stories in 1976 and 1977 at the Clarion Science Fiction Writers Workshop.

201. Born Ruth Weston, in Portsmouth, Virginia, she was Atlantic records first big hitmaker with five number one hits. With songs such as Mama, He Treats Your Daughter Mean, Teardrops From My Eyes, and Oh What a Dream, she was the Queen of Rhythm and Blues in the early 1950's.

202. Pregnant with twin daughters, mother of four daughters already, she saw her husband gunned down with sixteen bullets torturing his body in the

Audubon Ballroom on February 21, 1965. She works at the Medgar Evers College in Brooklyn, New York.

203. A former black panther, she was convicted of killing a police officer. She became one of America's most wanted after escaping prison and escaping to Cuba. Born Joanne Chesimard, she has written her story in an autobiography.

204. Born in Texas, in 1868, she was at one time a teacher in Austin, Texas. Founder of the Southside Settlement House in Chicago (1919), it was the first with a black staff that was primarily for blacks. By 1949 it had been renamed the McKinley House. Who was the founder?

205. The first black female mayor in the United States, she was elected mayor of Taft, Oklahoma in April of 1973. A high school graduate and mother of five, she was elected in an all black town of which the population was approximately 600.

206. Author of *Portraits in Color*, she once was a high school science teacher. Born in 1924, she received her law degree from the University of Miami, prior to becoming Florida's first elected black woman to its state legislature in 1970.

207. Elected as Wisconsin's Secretary of State in 1978, she was the first black female to win a state wide office. She was also, in 1956, elected as the first black woman to serve on the Milwaukee Common Council. In 1971, she was appointed as county judge, another first.

208. Born in Lawton, Oklahoma, she, in 1975, became the first black female superintendent of the Oakland Public Schools in California. In 1981, she accepted the challenge of the first woman and first black superintendent of the Chicago Public School System.

209. Born in 1860, she became the first black female to employed by the Office of the Recorder of Deeds in Washington D.C. in 1878. One of the original members of the Universal Negro Improvement Association in New York City, her career included teaching, singing and public speaker/organizer.

210. Born in Richmond, Virginia, she was raised in Rankin, Pennsylvania. She at one time, was a casemanager for the New York City Welfare Department, the 10th president of the Delta Sigma Theta Sorority, Inc. and president of the National Council of Negro Women. She was responsible for instituting, in 1986, the annual Black Family Reunion Celebration.

211. Known as Pennsylvania's lady of sculpture, she created the bust on the 10 cent coin of President Roosevelt. Born in North Carolina, she was the driving force behind many of Pennsylvania's' festivals of the fine arts.

212. Born in 1905, Des Moines, Iowa, her autobiography is called *American Daughter*. Her family was one of 617 blacks living in North Dakota in 1910. She used her journalistic talents with Ebony magazine, starting in 1945, and held various editorial positions for many years.

213. The first African-American female elected as a City Commissioner in the city of Philadelphia, she went on to become an elected city councilperson. A former staff person for former Congressman William Grey, she has strongly supported women and minority issues.

214. The first African-American woman to obtain an appointment to the cabinet of Pennsylvania's government, she was named Secretary of the State by Governor Milton Shapp in 1971. A native of Philadelphia, Pennsylvania, she received the 1961 NAACP Freedom Fund Award.

215. In 1948, she was the first black woman to run for Congress in the state of Missouri. In 1975, she was the first black women elected president of the National of Directors of the NAACP. A graduate of the Lincoln University School of Law in St. Louis, Missouri, she was also the first black female president of the St. Louis NAACP.

ANSWERS TO TRIVIA QUESTIONS

REF.	LAST NAME	FIRST NAME	MIDDLE NAME
1	Allen	Dr. Ethel	
2.	Burke	Yvonne	Braithwaite
3.	Coppin	Fannie	Jackson
4.	Dee	Ruby	
5.	Fields	Mary	
6.	Green	Nancy	
7.	Harper	Frances Ellen	Watkins
8.	Jones	Sissieretta	
9.	Mahoney	Mary	Eliza
10.	Nelson	Alice	Dunbar
11.	Pleasant	Mary	Ellen
12.	Patterson	Mary	Jane
13.	Ray	Charlotte	
14.	Smith	Bessie	
15.	Truth	Sojourner	
16.	Valdez	Marie	Vita
17.	Walker	Madame	C. J.
18.	Anderson	Dr. Caroline	Still
19.	Anderson	Marian	
20.	Africa	Ramona	
21.	Alexander	Sadie	
22.	Barnett	Ida	Wells
23.	Brown	Charlotte	Hawkins
24.	Bethune	Mary	McCleod

ANSWERS TO TRIVIA QUESTIONS

REF.	LAST NAME	FIRST NAME	MIDDLE NAME
25.	Chisholm	Shirley	
26.	Caddy	Mary Ann	Shadd
27.	Douglas	Sarah	Mapps
28.	Greenfield	Elizabeth	Taylor
29.	Harris	Patricia	Roberts
30.	Jordan	Barbara	
31.	Lee	Dr. Rebecca	
32.	Tubman	Harriet	
33.	Walker	Maggie	Lena
34.	Wheatley	Phyliss	
35.	Bowser	Mary	Elizabeth
36.	Norton	Eleanor	Holmes
37.	Grimke	Charlotte	Forten
38.	Metoyer	Marie	Therese
39.	Francis	Phoebe	
40.	Fuller	Meta Vaux	Warrick
41.	Johnson	Georgia	Douglas
42.	Mills	Florence	
43.	Jackson	May	Howard
44.	Savage	Augusta	
45.	Cole	Dr. Rebecca	
46.	Franklin	Aretha	
47.	Gray	Dr. Ida	
48.	Ferguson	Catherine	

ANSWERS TO TRIVIA QUESTIONS

REF.	LAST NAME	FIRST NAME	MIDDLE NAME
49.	Coleman	Bessie	
50.	McKinney	Nina	Mae
51.	Hamer	Fannie	Lou
52.	Ruffin	Josephine	St. Pierre
53.	Talbert	Mary	Burnett
54.	Taylor	Susie	King
55	Jones	Roxane	
56.	Waters	Ethel	
57.	Clayton	Dr. Constance	
58.	Motley	Constance	Baker
59.	Fausett	Jessie	Redmon
60.	Bolin	Janie	Matilda
61.	Terrell	Mary Eliza	Church
62.	Hayre	Dr. Ruth	
63.	McDaniel	Hattie	
64.	Lewis	Edmonia	
65.	Hansberry	Lorraine	
66.	Parks	Rosa	
67.	Bates	Daisy	Gatson
68.	Barrett	Janie	Porter
69.	Burroughs	Nannie	Helen
70.	Beacraft	Annie	Marie
71.	Baker	Josephine	
72.	Simms	Annie	Banks

ANSWERS TO TRIVIA QUESTIONS

REF.	LAST NAME	FIRST NAME	MIDDLE NAME
73.	Craft	Ellen	
74.	Frazier	Susie	Elizabeth
75.	Ayers	Elise	
76.	Gibson	Althea	
77.	Hurston	Zora	Neale
78.	Keckley	Elizabeth	
79.	Price	Florence Beatrice	Smith
80.	Stewart	Maria	
81.	Stewart	Dr. Susan	Smith McKinney
82.	Sanchez	Sonia	
83.	Terry	Lucy	
84.	Convent	Marie	Bernard
85.	Early	Sarah	J. W.
86.	Peake	Mary	Smith Kelsey
87.	Wright	Elizabeth	Evelyn
88.	Baldwin	Maria	Louise
89.	Brown	Rose	Butler
90.	Lang	Mary	Elizabeth
91.	Williams	Fannie	Barrier
92.	Laney	Lucy	Craft
93.	Davis	Angela	Yvonne
94.	Hall	Katie	
95.	Brown	Hallie	Quinn
96.	Edelman	Marian	Wright

ANSWERS TO TRIVIA QUESTIONS

REF.	LAST NAME	FIRST NAME	MIDDLE NAME
97.	Shange	Ntzoke	
98.	Walker	Margaret	
99.	Riboud	Barbara	Chase
100.	Hamilton	Grace	Towns
101.	Lawson	Majorie	
102.	Collins	Cardiss	
103.	Johnson	Violette	Anderson
104.	Jones	Clara	
105.	Stout	Juanita	Kidd
106.	Holliday	Billie	
107.	Ingram	Edith	
108.	Larsen	Nella	
109.	Angelou	Maya	
110.	Gannett	Deborah	
111.	Malone	Patty	
112.	Brown	Clara	
113.	Fayerweather	Sarah	Harris
114.	Bonds	Margaret	
115.	Jarboro	Caterina	
116.	Williams	Camilla	
117.	Dobbs	Mattiwilda	
118.	George	Dr. Zelma	
119.	Price	Leontyne	
120.	Arroyo	Martina	

ANSWERS TO TRIVIA QUESTIONS

REF.	LAST NAME	FIRST NAME	MIDDLE NAME
121.	Kitt	Eartha	
122.	Morrison	Toni	
123 .	Ti tuba		
124 .	Rainey	Ma	
125	Smith	Clara	
126.	Smith	Mamie	
127.	Mabley	Jackie	Moms
128.	Cox	Ida	
129.	Spivey	Victoria	
13 0 .	Hegamin	Luci ll e	
131.	Holt	Nora	
132 .	Hunter	Albert a	
133 .	Heyward	Dorothy	Kuhns
134.	Holloway	Lucy Ariel	Williams
135 .	Walker	A' Lelia	
136.	Waring	Laura	Wheeler
137.	Washington	Fredi	
138.	Fitzgerald	Ella	
139.	Horne	Lena	
140.	Dean	Lillian	Harris
141.	Dismond	Geraldyn	Hodges
142.	Dunham	Katherine	
143.	Scott	Hazel	
144.	Dandridge	Dorothy	

ANSWERS TO TRIVIA QUESTIONS

REF.	LAST NAME	FIRST NAME	MIDDLE NAME
145.	Odetta		
146.	Bailey	Pearl	
147.	Bryant	Joyce	
148.	Tyson	Cecily	
149.	Brooks	Gwendolyn	
150.	Redmond	Sarah	Parker
151.	Beasley	Delilah	Leontium
152.	Brooks	Elizabeth	Carter
153 .	Brown	Sue	
154.	Burwell	Mary	
155.	Cook	Myrtle	Foster
156.	Cooper	Dr. Anna	
157.	Davis	Elizabeth	Lindsay
158.	Garnett	Sarah	J. Smith
159.	Hackely	Emma	Azalia
16 0 .	Cuney-Hare	Maude	
161.	Mosell	Gertrude	Bustill
162 .	C ol l i ns	Marva	
163.	Childress	Alice	
164.	Walker	Alice	
165 .	Simpson	Lorna	
166.	Williams	Mary	Lou
167.	Vaugh	Sarah	
168.	Simone	Nina	

ANSWERS TO TRIVIA QUESTIONS

REF.	LAST NAME	FIRST NAME	MIDDLE NAME
169.	Jamison	Judith	
170.	Joyner	Florence	Griffith
171.	Mason	Biddy	
172 .	Winfrey	Oprah	
173.	Sampson	Edith	
174.	Williams	Vanessa	
175.	Jackson	Mahalia	
176.	Marvelettes		
177.	Latifah	Queen	
178.	Whitaker	Yolanda	Yo-Yo
179.	Lyte	M.C.	
180 .	Harmony		
181.	Ross	Diana	
182 .	Sister Soul jah		
183.	Fausett	Crystal	Byrd
184.	Rudolph	Wilma	
185.	Washington	Dinah	
186.	Wallace	Sippie	
187.	Goldberg	Whoopi	
188.	Smith	Amanda	Berry
189.	Baker	Ella	
190.	King	Coretta	Scott
191.	Jemison	Mae C.	
192.	Wesling	Dr. Frances	Cress

ANSWERS TO TRIVIA QUESTIONS

REF.	LAST NAME	FIRST NAME	MIDDLE NAME
193.	Malone	Annie	Turnbo
194.	Mallory	Arenia	Conelia
195.	Kane	Alice	Woodby
196.	Sessions	lucy	
197.	Taylor	Ruth	Carol
198.	Farmer	Karen	
199.	Evans	Dr. Matilda	Arabella
200.	Butler	Octavia	Estelle
201.	Brown	Ruth	
202.	Shabazz	Betty	
203.	Shakur	Assata	
204.	McKinley	Asa	
205.	Foley	Lelia	
206.	Cherry	Gwendolyn	
207.	Phillips	Vel	
208.	Love	Dr. Ruth	
209.	Davis	Henrietta	Vinton
210.	Height	Dorothy	
211.	Burke	Dr. Selma	
212.	Thompson	Era	Bell
213.	Tasco	Marian	
214.	Tucker	C. Delores	
215.	Wilson	Margaret	Bush

ALPHABETICAL LISTING OF 215 WOMEN

LAST NAME	FIRST NAME	MIDDLE NAME	REFERENCE
Africa	Ramona		20.
Alexander	Sadie		21.
Allen	Dr. Ethel		1.
Anderson	Marian		19.
Anderson	Dr. Caroline	Still	18.
Angelou	Maya		109.
Arroyo	Martina		120.
Ayers	Elise		75.
Bailey	Pearl		146
Baker	Ella		189.
Baker	Josephine		71.
Baldwin	Maria	Louise	88.
Barnett	Ida	Wells	22.
Barrett	Janie	Porter	68.
Bates	Daisy	Gatson	67.
Beacraft	Annie	Marie	70.
Beasley	Delilah	Leontium	151.
Bethune	Mary	McCleod	24.
Bolin	Janie	Matilda	60.
Bonds	Margaret		114.
Bowser	Mary	Elizabeth	35.
Brooks	Gwendolyn		149.
Brooks	Elizabeth	Carter	152.
Brown	Ruth		201.

ALPHABETICAL LISTING OF 215 WOMEN

LAST NAME	FIRST NAME	MIDDLE NAME	REFERENCE
Brown	Sue		153.
Brown	Rose	Butler	89.
Brown	Clara		112.
Brown	Hallie	Quinn	95.
Brown	Charlotte	Hawkins	23.
Bryant	Joyce		147.
Burke	Yvonne	Braithwaite	2.
Burke	Dr. Selma		211.
Burroughs	Nannie	Helen	69.
Burwell	Mary		154.
Butler	Octavia	Estelle	200.
Caddy	Mary Ann	Shadd	26.
Cherry	Gwendolyn		206.
Childress	Alice		163.
Chisholm	Shirley		25.
Clayton	Dr. Constance		57.
Cole	Dr. Rebecca		45.
Coleman	Bessie		49.
Collins	Cardiss		102.
Collins	Marva		162.
Convent	Marie	Bernard	84.
Cook	Myrtle	Foster	155.
Cooper	Dr. Anna		156.
Coppin	Fannie	Jackson	3.

ALPHABETICAL LISTING OF 215 WOMEN

LAST NAME	FIRST NAME	MIDDLE NAME	REFERENCE
Cox	Ida		128.
Craft	Ellen		73.
Cuney-Hare	Maude		160.
Dandridge	Dorothy		144.
Davis	Elizabeth	Lindsay	157.
Davis	Angela	Yvonne	93.
Davis	Henrietta	Vinton	209.
Dean	Lillian	Harris	140.
Dee	Ruby		4.
Dismond	Geraldyn	Hodges	141.
Dobbs	Mattiwilda		117.
Douglas	Sarah	Mapps	27.
Dunham	Katherine		142.
Early	Sarah	J. W.	85.
Edelman	Marian	Wright	96.
Evans	Dr. Matilda	Arabella	199.
Farmer	Karen		198.
Fausett	Crystal	Byrd	183.
Fausett	Jessie	Redmon	59.
Fayerweather	Sarah	Harris	113.
Ferguson	Catherine		48.
Fields	Mary		5.
Fitzgerald	Ella		138.
Foley	Lelia		205.

ALPHABETICAL LISTING OF 215 WOMEN

LAST NAME	FIRST NAME	MIDDLE NAME	REFERENCE
Francis	Phoebe		39.
Franklin	Aretha		46.
Frazier	Susie	Elizabeth	74.
Fuller	Meta Vaux	Warrick	40.
Gannett	Deborah		110.
;'Garnett	Sarah	J. Smith	158.
George	Dr. Zelma		118.
Gibson	Althea		76.
Goldberg	Whoopi		187.
Gray	Dr. Ida		47.
Green	Nancy		6.
Greenfield	Elizabeth	Taylor	28.
Grimke	Charlotte	Forten	37.
Hackely	Emma	Azalia	159.
Hall	Katie		94.
Hamer	Fannie	Lou	51.
Hamilton	Grace	Towns	100.
Hansberry	Lorraine		65.
Harmony			180
Harper	Frances Ellen	Watkins	7.
Harris	Patricia	Roberts	29.
Hayre	Dr. Ruth		62.
Hegamin	Lucille		130.
Height	Dorothy		210.

LAST NAME	FIRST NAME	MIDDLE NAME	REFERENCE
Heyward	Dorothy	Kuhns	133.
Holliday	Billie		106.
Holloway	Lucy Ariel	Williams	134.
Holt	Nora		131.
Home	Lena		139.
Hunter	Alberta		132.
Hurston	Zora	Neale	77.
Ingram	Edith		107.
Jackson	Mahalia		175.
Jackson	May	Howard	43.
Jamison	Judith		169.
Jarboro	Caterina		115.
Jemison	Mae C.		191.
Johnson	Violette	Anderson	103.
Johnson	Georgia	Douglas	41.
Jones	Clara		104.
Jones	Roxane		55.
Jones	Sissieretta		8.
Jordan	Barbara		30.
Joyner	Florence	Griffith	170.
Kane	Alice	Woodby	195.
Kecklely	Elizabeth		78.
King	Coretta	Scott	190.
Kitt	Eartha		121.

ALPHABETICAL LISTING OF 215 WOMEN

LAST NAME	FIRST NAME	MIDDLE NAME	REFERENCE
Laney	Lucy	Craft	92.
Lang	Mary	Elizabeth	90.
Larsen	Nella		108.
Latifah	Queen		177.
Lawson	Majorie		101.
Lee	Dr. Rebecca		31.
Lewis	Edmonia		64.
Love	Dr. Ruth		208.
Lyte	M.C.		179.
Mabley	Jackie	Moms	127.
Mahoney	Mary	Eliza	9.
Mallory	Arenia	Conelia	194.
Malone	Annie	Turnbo	193.
Malone	Patty		111.
Marvalettes			176
Mason	Biddy		171.
McDaniel	Hattie		63.
McKinley	Asa		204.
McKinney	Nina	Mae	50.
Metoyer	Marie	Therese	38.
Mills	Florence		42.
Morrison	Toni		122.
Mosell	Gertrude	Bustill	161.
Motley	Constance	Baker	58.

ALPHABETICAL LISTING OF 215 WOMEN

LAST NAME	FIRST NAME	MIDDLE NAME	REFERENCE
Nelson	Alice	Dunbar	10.
Norton	Eleanor	Holmes	36.
Odetta			145.
Parks	Rosa		66.
Patterson	Mary	Jane	12.
Peake	Mary	Smith Kelsey	86.
Phillips	Vel		207.
Pleasant	Mary	Ellen	11.
Price	Leontyne		119.
Price	Florence Beatrice	Smith	79.
Rainey	Ma		124.
Ray	Charlotte		13.
Redmond	Sarah	Parker	150.
Riboud	Barbara	Chase	99.
Ross	Diana		181.
Rudolph	Wilma		184
Ruffin	Josephine	St. Pierre	52.
Sampson	Edith		173.
Sanchez	Sonia		82.
Savage	Augusta		44.
Scott	Hazel		143.
Sessions	Lucy		196.
Shabazz	Betty		202.
Shakur	Assata		203.

ALPHABETICAL LISTING OF 215 WOMEN

LAST NAME	FIRST NAME	MIDDLE NAME	REFERENCE
Shange	Ntzoke		97.
Simms	Annie	Banks	72.
Simone	Nina		168.
Simpson	Lorna		165
Sister Souljah			182.
Smith	Amanda	Berry	188
Smith	Bessie		14.
Smith	Mamie		126.
Smith	Clara		125
Spivey	Victoria		129.
Stewart	Maria		80.
Stewart	Dr. Susan	Smith McKinney	81.
Stout	Juanita	Kidd	105.
Talbert	Mary	Burnett	53.
Tasco	Marian		213.
Taylor	Susie	King	54.
Taylor	Ruth	Carol	197.
Terrell	Mary Eliza	Church	61.
Terry	Lucy		83.
Thompson	Era	Bell	212.
Tituba			123
Truth	Sojourner		15.
Tubman	Harriet		32.
Tucker	C. Delores		214

ALPHABETICAL LISTING OF 215 WOMEN

LAST NAME	FIRST NAME	MIDDLE NAME	REFERENCE
Tyson	Cecily		148
Valdez	Marie	Vita	16.
Vaughn	Sarah		167.
Walker	Alice		164.
Walker	Margaret		98.
Walker	A'Lelia		135.
Walker	Madame	C. J.	17.
Walker	Maggie	Lena	33.
Wallace	Sippie		186.
Waring	Laura	Wheeler	136.
Washington	Dinah		185.
Washington	Fredi		137
Waters	Ethel		56
Wesling	Dr. Frances	Cress	192.
Wheatley	Phyliss		34.
Whitaker	Yolanda	Yo-Yo	178.
Williams	Camilla		116.
Williams	Mary	Lou	166.
Williams	Vanessa		174.
Williams	Fannie	Barrier	91.
Wilson	Margaret	Bush	215.
Winfrey	Oprah		172.
Wright	Elizabeth	Evelyn	87.

Many of the women selected to appear in this book has a life span that carries into at least 2 centuries. For most cases the woman is listed in the century in which her first and or greatest achievement occured.

1 6 0 0

	Tituba		123.

1 7 0 0

Beacraft	Annie	Marie	70.
Convent	Marie	Bernard	84.
Ferguson	Catherine		48.
Francis	Phoebe		39.
Gannett	Deborah		110.
Terry	Lucy		83.
Wheatley	Phyliss		34.

1800

Anderson	Dr. Caroline	Still	18.
Baldwin	Maria	Louise	88.
Barnett	Ida	Wells	22.
Beasley	Delilah	Leontium	151.
Bower	Mary	Elizabeth	35.
Brooks	Elizabeth	Carter	152.

Brown	Hallie	Quinn	95.
Brown	Charlotte	Hawkins	23.
Brown	Clara		112.
Caddy	Mary Ann	Shadd	26.
Cole	Dr. Rebecca		45.
Cooper	Dr. Anna		156.
Coppin	Fannie	Jackson	3.
Craft	Ellen		73.
Cuney-Hare	Maude		160.
Davis	Elizabeth	Lindsay	157.
Dean	Lillian	Harris	140.
Douglas	Sarah	Mapps	27.
Early	Sarah	J. W.	85.
Evans	Dr. Matilda	Arabella	199.
Fayerweather	Sarah	Harris	113.
Fields	Mary		5.
Frazier	Susie	Elizabeth	74.
Jarnett	Sarah	J. Smith	158.
Jray	Dr. Ida		47.
Greenfield	Elizabeth	Taylor	28.
Grimke	Charlotte	Forten	37.
Hackely	Emma	Azalia	159.
Harper	Frances Ellen Watkins		7.
Jones	Sissieretta		8.
Kane	Alice Woodby	195.	

Kecklely	Elizabeth		78.
Laney	Lucy	Craft	92.
Lang	Mary	Elizabeth	90.
Lee	Dr. Rebecca		31.
Lewis	Edmonia		64.
Mahoney	Mary	Eliza	9.
Malone	Patty		111.
Mason	Biddy		171.
Metoyer	Marie	Therese	38.
Mosell	Gertrude	Bustill	161.
Nelson	Alice	Dunbar	10.
Patterson	Mary	Jane	12.
Peake	Mary	Smith Kelse 86.	
Pleasant	Mary	Ellen	11.
Ray	Charlotte		13.
Redmond	Sarah	Parker	150.
Sessions	Lucy		196.
amith	Amanda	Berry	188.
Stewart	Dr. Susan	Smith McKin	81.
Stewart	Maria		80.
Taylor	Susie	King	54.
Terrell	Mary Eliza	Church	61.
Truth	Sojourner		15.
Tubman	Harriet		32.
Valdez	Marie	Vita	16.

Wright	Elizabeth	Evelyn	87.
1900			
Africa	Ramona		20.
Alexander	Sadie		21.
Allen	Dr. Ethel		
Anderson	Marian		19.
Angelou	Maya		109.
Arroyo	Martina		120.
Ayers	Elise		75.
Bailey	Pearl		146.
Baker	Ella		189.
Baker	Josephine		71.
Barrett	Janie	Porter	68.
Bates	Daisy	Gatson	67.
Bethune	Mary	McCleod	24.
Bolin	Janie	Matilda	60.
Bonds	Margaret		114.
Brooks	Gwendolyn		149.
Brown	Sue		153.
Brown	Rose	Butler	89.
Brown	Ruth		201.
Bryant	Joyce		147.
Burke	Yvonne	Braithwaite	2.

Burke	Dr. Selma		211.
Burroughs	Nannie	Helen	69.
Burwell	Mary		154.
Butler	Octavia	Estelle	200.
Cherry	Gwendolyn		206.
Childress	Alice		163.
Chisholm	Shirley		25.
Clayton	Dr. Constance		57.
Coleman	Bessie		49.
Collins	Marva		162.
Collins	Cardiss		102.
Cook	Myrtle	Foster	155.
Cox	Ida		128.
Dandridge	Dorothy		144.
Davis	Angela	Yvonne	93.
Davis	Henrietta	Vinton	209.
Dee	Ruby		4.
Dismond	Geraldyn	Hodges	141.
Dobbs	Mattiwilda		117.
Dunham	Katherine		142.
Edelman	Marian	Wright	96.
Farmer	Karen		198.
Fausett	Crystal	Byrd	183.
Fausett	Jessie	Redmon	59.
Fitzgerald	Ella		138.

Foley	Lelia		205.
Franklin	Aretha		46.
Fuller	Meta Vaux	Warrick	40.
George	Dr. Zelma		118.
Gibson	Althea		76.
Goldberg	Whoopi		187.
Green	Nancy		6.
Hall	Katie		94.
Hamer	Fannie	Lou	51.
Hamilton	Grace	Towns	100.
Hansberry	Lorraine		65.
Harris	Patricia	Roberts	29.
Hayre	Dr. Ruth		62.
Hegamin	Lucille		130.
Height	Dorothy		210.
Heyward	Dorothy	Kuhns	133.
Holliday	Billie		106.
Holloway	Lucy Ariel	Williams	134.
Holt	Nora		131.
Horne	Lena		139.
Hunter	Alberta		132.
Hurston	Zora	Neale	77.
Ingram	Edith		107.
Jackson	Mahalia		175.
Jackson	May	Howard	43.

Jamison	Judith		169.
Jarboro	Caterina		115.
Jemison	Mae C.		191.
Johnson	Georgia	Douglas	41.
Johnson	Violette	Anderson	103.
Jones	Clara		104.
Jones	Roxane		55.
Jordan	Barbara		30.
Joyner	Florence	Griffith	170.
King	Coretta	Scott	190.
Kitt	Eartha		121.
Larsen	Nella		108.
Latifah	Queen		177.
Lawson	Majorie		101.
Love	Dr. Ruth		208.
Lyte	M.C.		179.
Mabley	Jackie	Moms	127.
Mallory	Arenia	Conelia	194.
Malone	Annie	Turnbo	193.
McDaniel	Hattie		63.
McKinley	Asa		204.
McKinney	Nina	Mae	50.
Mills	Florence		42.
Morrison	Toni		122.
Motley	Constance	Baker	58.

Nelson	Alice	Dunbar	10.
Norton	Eleanor	Holmes	36.
Parks	Rosa		66.
Phillips	Vel		207.
Price	Leontyne		119.
Price	Florence Beatr Smith		79.
Rainey	Ma		124.
Riboud	Barbara	Chase	99.
Ross	Diana		181.
Rudolph	Wilma		184.
Ruffin	Josephine	St. Pierre	52.
Sampson	Edith		173.
Sanchez	Sonia		82.
Savage	Augusta		44.
Scott	Hazel		143.
Shabazz	Betty		202.
Shakur	Assata		203.
Shange	Ntzoke		97.
Simms	Annie	Banks	72.
Simone	Nina		168.
Simpson	Lorna		165.
Smith	Bessie		14.
Smith	Mamie		126.
Smith	Clara		125.
Spivey	Victoria		129.

Stout	Juanita	Kidd	105.
Talbert	Mary	Burnett	53.
Tasco	Marian		213.
Taylor	Ruth	Carol	197.
Thompson	Era	Bell	212.
Tucker	C. Delores		214.
Tyson	Cecily		148.
Vaugh	Sarah		167.
Walker	Alice		164.
Walker	Margaret		98.
Walker	Madame	C. J.	17.
Walker	Maggie	Lena	33.
Walker	A'Lelia		135.
Wallace	Sippie		186.
Waring	Laura	Wheeler	136.
Washington	Dinah		185.
Washington	Fredi		137.
Waters	Ethel		56.
Wesley	Dr. Frances	Cress	192.
Whitaker	Yolanda	Yo-Yo	178.
Williams	Camilla		116.
Williams	Mary	Lou	166.
Williams	Vanessa		174.
Williams	Fannie	Barrier	91.
Wilson	Margaret	Bush	215.

Some of the women can be placed in 2 or more categories. For these women, they are, as a rule, placed in the career category for which they achieved the most success.

Actress

Dandridge	Dorothy		144
Dee	Ruby		4
Kitt	Eartha		121
McDaniel	Hattie		63
McKinney	Nina Mae		50
Mi ll s	Florence		42
Tyson	Cecily		148
Washington	Fredi		137

Airline Stewardess

Taylor	Ruth	Carol	197

Art

Burke	Dr. Selma		211
Fuller	Meta Vaux	Warrick	40
Jackson	May	Howard	43
Lewis	Edmonia		64
Savage	Augusta		44
Simpson	Lorna		165
Waring	Laura	Wheeler	136

Art/Author

Riboud	Barbara	Chase	99

Astronaut

Jemison	Mae C.		191

Athlete

Gibson	Althea		76
Joyner	Florence	Griffith	170

Rudolph	Wilma		184

Author

Hurston	Zora	Neale	77
Nelson	Alice	Dunbar	10

Author/Publisher

Angelou	Maya		109
Beasley	Delilah	Leontium	5
Brooks	Gwendolyn		149
Brown	Sue		153
Butler	Octavia	Estelle	200
Caddy	Mary Ann	Shadd	26
Childress	Alice		163
Fausett	Jessie	Redmon	59.
Hansberry	Lorraine		65
Harper	Frances Ellen Watkins		7
Heyward	Dorothy	Kuhns	133
Johnson	Georgia	Douglas	41
Larsen	Nella		108
Morrison	Toni		122
Mosell	Gertrude	Bustill	161
Ruffin	Josephine	St . Pierre	52
Sanchez	Sonia		82
Shange	Ntzoke		97
Terry	Lucy		83
Walker	Margaret		98
Walker	Alice		164
Wheatley	Phyliss		34

Business

Convent	Marie	Bernard	84
Cook	Myrtle	Foster	155
Dean	Lillian	Harris	140
Pleasant	Mary	Ellen	11
Valdez	Marie	Vita	16

| Walker | Madame | C. J. | 17 |
| Walker | Maggie | Lena | 33 |

Club Organizer

)avis	Elizabeth	Lindsay	157
Early			
Early	Sarah	J. W.	85

Educator

Ayers	Elise		75
Baldwin	Maria	Louise	88
Beacraft	Annie	Marie	70
Bethune	Mary	McCleod	24
Brooks	Elizabeth	Carter	152
Brown	Charlotte	Hawkins	23
Brown	Hallie	Quinn	95
Brown	Rose	Butler	89
Burroughs	Nannie	Helen	69
Clayton	Dr. Constance		57
Collins	Marva		162
Cooper	Dr. Anna		156
Coppin	Fannie	Jackson	3
Douglas	Sarah	Mapps	27
Fayerweather	Sarah	Harris	113
Frazier	Susie	Elizabeth	74
Garnett	Sarah	J. Smith	158
Grimke	Charlotte	Forten	37
Hayre	Dr. Ruth		62
Height	Dorothy		210
Holloway	Lucy Ariel	Williams	134
Kane	Alice	Woodby	195
Janey	Lucy	Craft	92
Jove	Dr. Ruth		208
Mallory	Arenia	Conelia	194
Malone	Annie	Turnbo	193
Patterson	Mary	Jane	12

Peak	Mary	Smith Kels	86
Sessions	Lucy		196
Talbert	Mary	Burnett	53
Terrell	Mary Eliza	Church	61
Williams	Fannie	Barrier	91
Wright	Elizabeth	Evelyn	87

Entertainer

Bailey	Pearl		146
Dunham	Katherine		142
Goldberg	Whoopi		187
Horne	Lena		139
Jamison	Judith		169
Mabley	Jackie	Moms	127
Ross	Diana		181

First Black Miss America

| Williams | Vanessa | | 174 |

Freedom Fighter

Africa	Ramona		20
Baker	Ella		189
Garnett	Ida	Wells	22
Bates	Daisy	Gatson	67
Davis	Angela	Yvonne	93
King	Coretta	Scott	190
?arks	Rosa		66
Redmond	Sarah	Parker	150
Shabazz	Betty		202
Shakur	Assata		203
Truth	Sojourner		15
Tubman	Harriet		32

Movement

| Harris | Patricia | Roberts | 29 |
| Norton | Eleanor | Holmes | 36 |

Tucker	C. Delores		214
Walker	A'Lelia		135

Journalism

Thompson	Era	Bell	212
Stewart	Maria		80
Alexander	Sadie		21
Bolin	Janie	Matilda	60
Edelman	Marian	Wright	96
Ingram	Edith		107
Johnson	Violette	Anderson	103
Lawson	Majorie		101
Motley	Constance	Baker	58
Ray	Charlotte		13
Sampson	Edith		173
Stout	Juanita	Kidd	105
Jones	Clara		14

Lifesaver

Francis	Phoebe		39

Living trademark

Green	Nancy		6

Medical

Allen	Dr. Ethel		1
Anderson	Dr. Caroline Still		18
Cole	Dr. Rebecca		45
Evans	Dr. Matilda Arabella		199
Gray	Dr. Ida		47
Lee	Dr. Rebecca		31
Mahoney	Mary	Eliza	9
Stewart	Dr. Susan	Smith McKinney	81
Taylor	Susie	King	54
Wesley	Dr. Frances	Cress	192

Member of DAR

Farmer	Karen		19

Music

Anderson	Marian		19
Arroyo	Martina		120
Baker	Josephine		71
Bonds	Margaret		114
Brown	Ruth		201
Bryant	Joyce		147
Cox	Ida		128
Cuney-Hare	Maude		160
Dobbs	Mattiwilda		117
Fitzgerald	Ella		138
Franklin	Aretha		46
George	Dr. Zelma		118
Greenfield	Elizabeth	Taylor	28
Hackely	Emma	Azalia	159
Harmony			180
Hegamin	Lucille		130
Holliday	Billie		106
Holt	Nora		131
Hunter	Alberta		132
Jackson	Mahalia		175
Jarboro	Caterina		115
Jones	Sissieretta		8
Latifah	Queen		177
Lyte	M.C.		179
Malone	Patty		111
Marvelettes			176
Odetta			145
Price	Leontyne		119
Price	Florence Beatrice Smith		79
Rainey	Ma		124
Scott	Hazel		143
Simone	Nina		168

Sister Souljah			182
Smith	Bessie		14·
Smith	Mamie		126
Smith	Clara		125
Spivey	Victoria		129
Vaughn	Sarah		167
Wallace	Sippie		186
Washington	Dinah		185
Waters	Ethel		56
Whitaker	Yolanda	Yo-Yo	178
Williams	Mary	Lou	166
Williams	Camilla		116

Pilot
Coleman	Bessie		49

Engineer
Brown	Clara		112
Jason	Biddy		171

Plantation Owner
Metoyer	Marie	Therese	38

Politics
Burke	Yvonne	Braithwait	2
Cherry	Gwendolyn		206
Chisholm	Shirley		25
Collins	Cardiss		102
Fausett	Crystal	Byrd	183
Foley	Lelia		205
Hall	Katie		94
Hamer	Fannie	Lou	51
Hamilton	Grace	Towns	100
Jones	Roxane		55
Jordan	Barbara		30
Nelson	Alice	Dunbar	10

Phillips	Vel		207
Simms	Annie	Banks	72
Tasco	Marian		213
Wilson	Margaret	Bush	215

Public

Davis	Henrietta	Vinton	209

Radio Announcer

Dismond	Geraldyn	Hodges	141

Religion

Burwell	Mary		154
Ferguson	Catherine		48
Lang	Mary	Elizabeth	90
Smith	Amanda	Berry	188
Tituba			123

Runaway Slave

Craft	Ellen	73
Kecklely	Elizabeth	78

Social Work

Barrett	Janie	Porter	68
McKinley	Asa		204

Soldier

Gannett	Deborah	110

Stagecoach Driver

Fields	Mary	5

Talk Show Host

Winfrey	Oprah	172

Union Spy

| Bowser | Mary | Elizabeth | 35 |

RECOMMENDED READING

The Afro-American Woman: Struggles and Images; Sharon Harley and Rosalyn Terborg-Penn, editors. Port Washington, New York, Kennikat Press, 1978 .

American Black Women in the Arts and Social Sciences: A Bibliographic Survey, 1973; By Ora Williams. Metuchen, N.J. & London, 1978

Beautiful, Also Are the Souls of My Black Sisters; By Jean Noble. (Englewood Cliffs, N.J., Prentice-Hall, Inc., 1978

Black Book of Heroes Volume 2, Great Women in the Struggle; Toyomi Igus, editor. (Just Us Books, Orange, N.J., 1991

Blackforemothers by Dorothy Sterling. (NY, Feminist Press, 1988)

Black Legislators in Pennsylania's History (1911-1984); compiled by Mattie McKinney (Pa. State Legislature)

Black Pearls, Blues Queens of the 1920's; by Daphne Duval Harrison (Rutgers University Press, 1990)

The Black Woman: A Figure In World History, Part 1, by John Henrik Clark; article in May 1971 Essence.

Black Women in Nineteenth Century American Life; Bert James Loewenberg and Ruth Bogin, editors; (University Park Pennsylvania State University Press, 1976)

Black Women Makers of History, A Portrait; by George F. Jackson (Oakland, California GRT Book Printing, 1985)

The Black West by William Katz (Anchor, Doubleday, 1973)

Black Women in White America: A Documentary History; Gerda Lerner, editor (NY: Random House, 1972)

But Some of Us are Brave: Black Women's Studies; Gloria Hull, Patricia Bell Scott and Barbara Smith, editors (New York: The Feminist Press, 1982)

Blacks in Classical Music by Raoul Abdul (Ny, Dodd, Mead and Company, 1977)

Brown Sugar: Eighty Years of America's Black Female Superstars by Donald Bogle (NY, Harmony Books, 1980)

Encyclopedia of Black America; W. Augustus Low and Virgil A. Clift, editors (NY, Da Capo Press Inc., 1981)

From Slavery to Freedom by John Hope Franklin; (NY, Alfred A. Knopf, Inc. 1974)

Harlem Renaissance: A Historical Dictionary for the Era; Bruce Kelner, editor (Westport, CT., Greenwood Press, 1984)

Liberty's Women; Robert McHenry, editor; (Springfield, Massachusetts, G&C Merriam Co., 1980)

Nation Conscious Rap; Joseph Eure and James Spady, editors (NY, PC International Press, 1992)

Profiles of Negro Womanhood, Volumes I and Volumes II, by Sylvia G. Dannett (Yonkers, N.Y., Negro Heritage Library, 1964)

Salute to Historic Black Women; Richard L. Green, editor (Chicago, Empak Publishing, 1988)

We are Your Sisters: Black Women in the 19th Century by Dorothy Sterling; (NY, WW Norton & Co., 1984)

When and Where I Enter: The Impact of Black Women on Race and Sex in America by Paula Giddins (NY., William Morrow, 1984)

Gloria L. Gaymon
P.O. BOX 6515
PHILADELPHIA, PA. 19138

NAME _____

ADDRESS _____

CITY_____ STATE_____

TELEPHONE_____

PLEASE INCLUDE $13.00 FOR EACH COPY (POSTAGE AND
HANDLING INCLUDED)

AMOUNT ENCLOSED_____

CHECK OR MONEY ORDER ONLY, NO CASH PLEASE

QUANTITY ORDERED _____

DISCOUNTS AVAILABLE FOR 5 OR MORE COPIES

About The Author

Gloria Leaks Gaymon was born June 7, 1952 in Silverstreet, South Carolina. A 1970 graduate of Simon Gratz High School in Philadelphia, she majored in History and Education at the University of Pennsylvania, graduating in 1974. A history teacher in the Philadelphia Public School System, she is also a member of the Democratic Executive Committee of the 10th Ward in the Oak Lane section of Philadelphia. Secretary of both her neighborhood block association and family (Spearman) organization, she enjoys taking historical information and making it enjoyable.